SQUIGGLES

&

SCRIBBLES

75 starter squiggles to spark your imagination

DENISE HARTZLER

LOOK UP
PUBLICATIONS

Published by Look Up Publications, LLC in 2020
First Edition; First Printing

Design, Cover, and Writing © 2020 Denise Hartzler

www.denisehartzler.com

ISBN: 978-1-7346070-1-7

DEDICATION

This book is dedicated to children & adults who need a brain break from our electronic world.

WHAT'S A STARTER SQUIGGLE?

Welcome to the *Squiggles & Scribbles* doodling book!

What's a starter squiggle, you ask?

No one likes the pressure of facing a blank piece of paper.

It's intimidating.

That's why I compiled a bunch of starter squiggles that allow your creativity to flow freely. When we begin to doodle with basic shapes, such as lines, circles, triangles, or a combination of them, relaxation begins.

While most journals and doodling books are smaller in size,
I made this book with traditional 8.5 x 11 paper.
Having a larger space allows for more opportunities to fill the whole page with random doodles or doodles that make a scene.
I also took kids into consideration!
Traditional-sized paper also allows young doodlers the space they need to showcase their creativity.

Doodling can be whimsical, messy, nonsensical, or stunning — it is entirely up to you!

So grab your favorite doodling pens, pencils, crayons, or markers, and scribble away!

·|∧∩☺ℓ ○○△□⌂❀

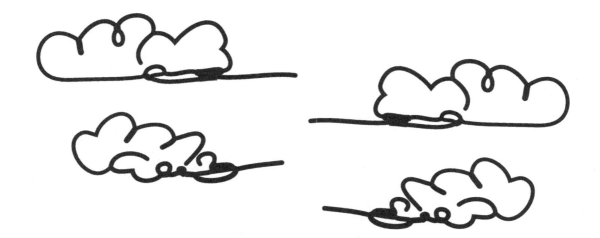

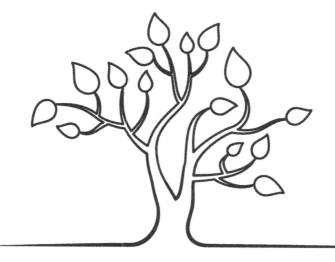

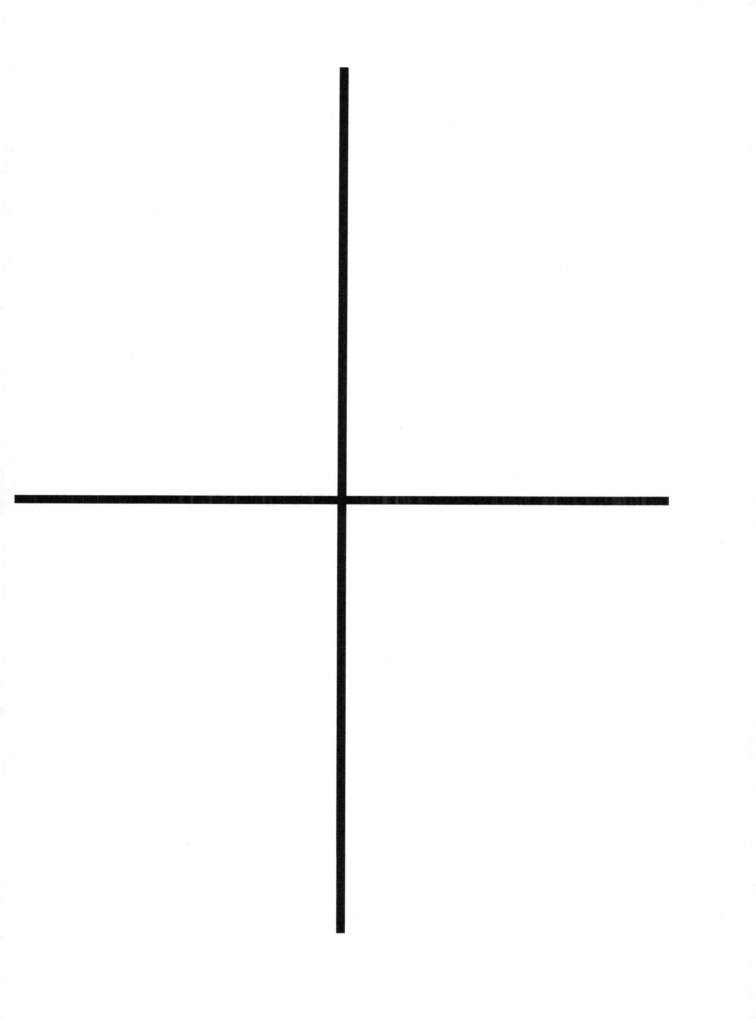

Bonus page:
Close your eyes and make a quick scribble on this page.
Now you have a new starter squiggle!

Bonus page:
ose your eyes and with your right hand make a quick scribble on this page.
Now you have a new starter squiggle!

Bonus page:
Close your eyes and with your left hand make a quick scribble on this page
Now you have a new starter squiggle!

Bonus page:
Give someone else your pen, have them close their eyes and
make a quick scribble on this page.

Made in the USA
Las Vegas, NV
22 December 2020